Jasper Johns:
From Plate to Print

Jasper Johns:
From Plate to Print

Elizabeth C. DeRose

Yale University Art Gallery
New Haven, Connecticut

First published in 2006 by the
Yale University Art Gallery
P.O. Box 208271
New Haven, CT 06520-8271
www.artgallery.yale.edu

Published in conjunction with the exhibition *Jasper Johns: From Plate to Print*,
organized by the Yale University Art Gallery

December 10, 2006–April 1, 2007

This exhibition and publication are made possible by the Florence B. Selden and the Heald Foundation Funds for Prints,
Drawings, and Photographs, with additional support provided by Mr. and Mrs. Alexander K. McLanahan, B.A. 1949.

Figs. 1–2: Courtesy O. Zimmermann, Musée d'Unterlinden, 68000 Colmar, France

Editor: Tiffany Sprague
Copyeditor: David Frankel

Library of Congress Cataloging-in-Publication Data
DeRose, Elizabeth C., 1975–
Jasper Johns: from plate to print/Elizabeth C. DeRose.
 p. cm.
Published in conjunction with the exhibition organized by the Yale University Art Gallery, Dec. 10, 2006–
Apr. 1, 2007.
Includes bibliographical references and index.
ISBN 0-89467-963-5 (alk. paper)
1. Johns, Jasper, 1930—Exhibitions. I. Johns, Jasper, 1930– II. Yale University. Art Gallery. III. Title.
NE539.J57A4 2006
769.92—DC22
2006023576

10 9 8 7 6 5 4 3 2 1

Cover (front and back): Jasper Johns, *Untitled,* 1999 (detail). Etching in five colors with sugar-lift, aquatint, spit bite, and drypoint
on Hahnemühle copperplate paper, 17 $^{15}/_{16}$ × 12 in. (45.5 × 30.5 cm) (plate), 27 $^1/_4$ × 19 $^3/_4$ in. (69.2 × 50.2 cm) (sheet). Edition 37.
Printed and published by Low Road Studio, Sharon, Conn. Katharine Ordway Fund and Gift of the artist in honor of Richard S.
Field. 2000.2.1–.42. **Frontispiece:** Detail of the first-state proof (cat. 2) of *Untitled,* 1999, digitally altered to print in black

Contents

7 Director's Foreword

10 Introduction

14 The Motif

26 The Key-Plate Design
 (The State Proofs)

36 The Elements and Progressives

40 The Trial Proofs

44 Conclusion

47 Notes

52 The Archive of *Untitled* (1999)

Director's Foreword

The Yale University Art Gallery is honored to present *Jasper Johns: From Plate to Print* as one of three special exhibitions that have been organized to help celebrate the reopening of the Gallery's landmark Louis Kahn building. This focused exhibition traces the development of Johns's intaglio print *Untitled* (1999) from its inception to its completion, offering students, faculty members, and our public visitors an unprecedented opportunity to visually follow one of the preeminent artists of our time through his process of artistic creation. This didactic display of graphic art also helps fortify our central mission of encouraging an appreciation and understanding of art and its role in society through direct engagement with original works.

The Gallery acquired *Untitled* (1999), along with its working proofs, trial proofs, elements, and progressives, in honor of Richard S. Field as he prepared to retire after twenty years of loyal service as Curator of Prints, Drawings, and Photographs. These purchases were made through the support of the Katharine Ordway Fund and were generously supplemented by the artist's own donation in 2000, gifted in honor of Field. One of the leading Jasper Johns print scholars, Field has written extensively on the artist and is the author of two catalogues raisonnés of his printed work. This year, Johns graciously presented the Gallery with the five copper plates he used to print *Untitled* (1999), thereby creating a complete visual archive for this particular printmaking project. This extraordinary set of materials will henceforth offer generations of students, artists, scholars, and other visitors to the Gallery's James E. Duffy Study Room for Prints, Drawings, and Photographs an exceptional means of contemplating the working process of one of America's most distinguished artists.

And how appropriate this is, for Johns has had a long association with this teaching museum, first showing his masterpiece *White Flag* (1955) (now in the collection of the Metropolitan Museum of Art) here from 1972 to 1973. He more recently shared his work with this university through another fine exhibition,

Jasper Johns: New Paintings and Works on Paper, which was organized in 1999 by the San Francisco Museum of Modern Art in collaboration with the Yale University Art Gallery.

It has been a great pleasure to give Elizabeth DeRose, our current Florence B. Selden Curatorial Assistant in the Department of Prints, Drawings, and Photographs, the opportunity to organize *Jasper Johns: From Plate to Print.* This is very appropriately the first professional curatorial and publishing project she has undertaken in her promising young career. The project has been generously supported by both our Florence B. Selden and Heald Foundation Funds.

DeRose, the Gallery staff, and I owe our warmest thanks to Jasper Johns himself who, in addition to his gracious donations, has lent four related prints to this exhibition to further amplify this intimate portrait of his creative process. We extend our sincere appreciation to master printer John Lund for his willingness to contribute his time and expertise, and to Sarah Taggart, Johns's assistant, for her help with many facets of the exhibition and its catalogue. We thank David Frankel for his thorough editing and insightful read of the catalogue essay. We also wish to honor, with our gratitude, Richard Field for his continued support, expert insights, and good advice.

On the Gallery's own staff, appreciation is to be given to Suzanne Boorsch, Curator of Prints, Drawings, and Photographs, for her encouragement of DeRose, and to Lisa Hodermarsky, Associate Curator of Prints, Drawings, and Photographs, for her essential guidance of all aspects of exhibition planning and creation of the exhibition catalogue. In addition to their thoughtful mentoring, it is a distinct pleasure to thank the following Gallery staff whose dedication and collective efforts made this project possible: Suzanne Greenawalt, Museum Assistant, for her administrative assistance, patience, and support; Diana Brownell, Museum Preparator, for meticulously matting and framing all of the prints; Clark Crolius, Manager of Installations, and his enthusiastic crew for

installing the exhibition; Christopher Sleboda, Director of Graphic Design, for his thoughtful design of the exhibition and catalogue; Janet Sullivan, Assistant Manager of Digital Media, and Senior Photographers Susan Cole and Anthony DeCamillo for their commitment to producing the highest-quality photographs; Anna Hammond, Deputy Director for Education, Programs, and Public Affairs, and her colleagues for their assistance with exhibition-related programming; Amy Jean Porter, Associate Director of Communications, for her creative energy and promotion of this exhibition; and Tiffany Sprague, Associate Editor, for steadfastly editing all copy of the catalogue and overseeing its production. Elizabeth DeRose would also like to especially join in acknowledging the late Florence B. Selden, whose enlightened philanthropy and interest in young learners has provided her with a unique opportunity to also work from "start to finish" in a very full and creative manner.

Jock Reynolds
The Henry J. Heinz II Director
Yale University Art Gallery

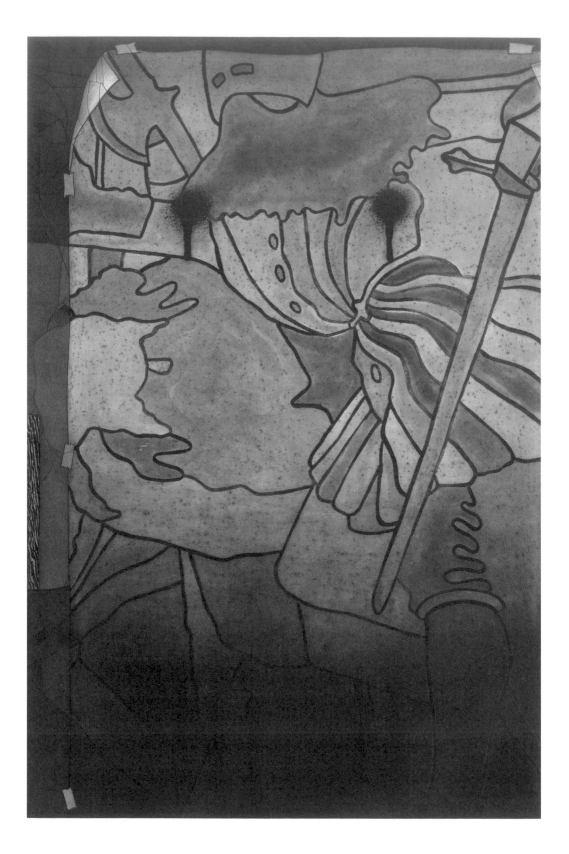

Introduction

A master of the techniques of intaglio, lithography, and screenprinting, Jasper Johns was instrumental in fostering the American print renaissance of the 1960s and 1970s and has made over three hundred prints since 1960, when he created his celebrated lithographs *Target* and *0 through 9*.[1] Marrying the process of printmaking with his work in paint, Johns visualizes the transfer of information that occurs in printmaking and exploits the intrinsic characteristics of the medium: mark making, replication, reversal, layering, fragmentation, and memory. "I like to repeat an image in another medium," he has said, "to observe the play between the two: the image and the medium. In a sense, one does the same thing two ways and can observe differences and sameness—the stress the image takes in different media."[2] No contemporary artist treats the medium this intricately, or repeats motifs from project to project in quite this serial way, although repetition is not Johns's intention: he is manipulating his motifs in fresh contexts, defining, clarifying, and transforming them, playing with subtle shifts. Even when he reuses old plates, he may cut and rearrange them, remove an image from an earlier work, or reinterpret a motif in a different printmaking technique.

Printmaking is so vital to Johns's activities that in 1996 he installed a print studio next to his painting studio on his property in Sharon, Connecticut, and invited the master printer John Lund, formerly of Universal Limited Art Editions (ULAE), Long Island, to work with him full time.[3] This arrangement enables Johns to work at will on his prints, free of the constraints of time and finances that overshadow the traditional collaborative process: "He was making prints with other people and was very concerned with time, money, and making them a success. Now, having a private shop, he can do much more experimenting, and prints without having an edition in mind."[4]

Although Johns's arrangement with Lund is not unique, it involves a striking departure from his earlier practices. He had previously worked at a

range of workshops with different master printers known for their expertise in particular media: for direct lithography, he most often worked with Ken Tyler of Gemini G.E.L.; for offset lithography, with Bill Goldston of ULAE; for etching, with Aldo Crommelynck in association with Petersburg Press; and for screenprinting, with Hiroshi Kawanishi of Simca Print Artists. In the last ten years, Johns has worked solely with Lund at his private shop, the Low Road Studio, removing himself from the social atmosphere of the larger presses and creating a more solitary environment similar to that of his painting studio.[5] He has also worked primarily in etching, an intaglio technique that allows great variation in surface and texture: the copper plate can store multiple layers of information, can be constantly reworked, or can be cut and rearranged to create new motifs.[6] All of these intrinsic properties appeal to Johns's sensibilities and working methods.

This exhibition marks an unprecedented opportunity to explore a single printmaking project from inception to completion. One of the remarkable and unique aspects of Johns's printmaking practice is that he pulls proofs at each stage of production, creating complete archives of all of his projects that allow the viewer to glimpse him at work—to see how he conceives and details his compositions, resolves their color and tonality, and manipulates their volumes.[7] In 2000 the Yale University Art Gallery acquired one such archive, for the intaglio *Untitled* (1999; cat. 1), including all of the working proofs, trial proofs, elements, and progressives. In 2006 Johns donated to the Gallery the five copper plates used to produce the print, completing this comprehensive set.[8] With its complex manipulation of a broad range of intaglio techniques, its Johnsian tricks, and its hallmark treatment of the figures, *Untitled* (1999) is an exemplary model through which to deconstruct and explore Johns's process.

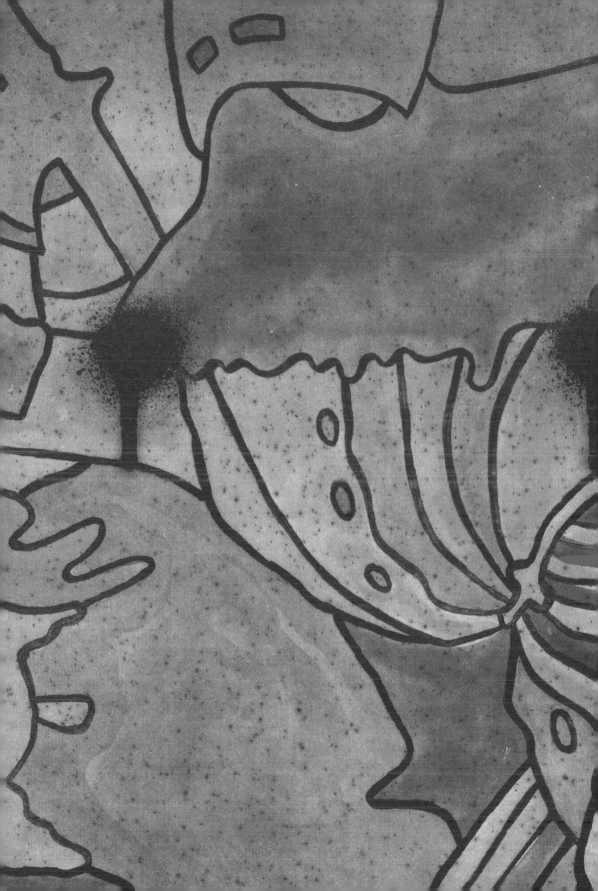

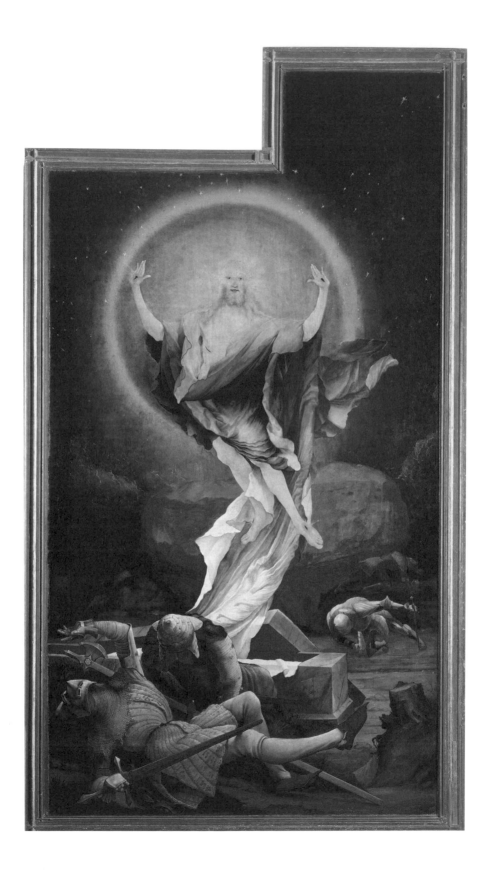

The Motif

In 1976 and 1979, Johns visited the masterpiece of the German Renaissance artist Matthias Grünewald, an altarpiece painted in the early sixteenth century for the hospital chapel of the monastery of Saint Anthony at Isenheim, Alsace, and now installed at the Musée d'Unterlinden in Colmar, France (fig. 1).[9] In the early 1980s, Johns began appropriating images of secondary figures from this painting in his work, tracing their outlines from a portfolio of reproductions that he had received as a gift: "I was attracted to the qualities conveyed by the delineation of the forms and I wanted to see if this might be freed from the narrative. I hoped to bypass the expressiveness of the imagery, yet to retain the expressiveness of the structure."[10] The two fallen soldiers in the foreground of the *Resurrection* panel of the altarpiece (fig. 2) provide the central motif in *Untitled* (1999). They first surfaced in Johns's work in 1982, in the monumental painting *Perilous Night* (fig. 3), where they appear twice: on the left side of the canvas they are loosely traced in red, reversed, and aligned vertically (that is, turned ninety degrees); the tracing is discreetly repeated in the middle of the right panel, now in the correct orientation but obscured by the handling of the encaustic paint. Johns has further exploited this pair in subsequent paintings and prints.[11]

The expressive physicality of Grünewald's soldiers is transformed in the context of Johns's art. The sixteenth-century viewer, versed in the stories of the life and death of Christ, would have had a ready understanding of the two men's presence in the *Resurrection* panel: ordered to guard Christ's tomb, they lie frozen in the extreme foreground, knocked flat by the power and glory of the Resurrection. Johns's ambiguous twentieth-century appropriation of these awe-struck figures has spawned a critical debate, one reflecting a persistent need to reconcile them with the self-referential nature of much of Johns's work.[12] If we insist on a symbolic interpretation of the subject, at least two, albeit conflicting ones, are readily plausible given the treatment of the image in *Untitled* (1999): the first finds a heroic soldier charging out of the darkness; the second, a

Fig. 1. Matthias Grünewald, *Resurrection* panel from the *Isenheim Altarpiece*, ca. 1515. Oil on wood, 105 ⅞ × 55 ½ in. (269 × 141 cm). Musée d'Unterlinden, Colmar, France. **Fig. 2 (overleaf):** Detail of fig. 1

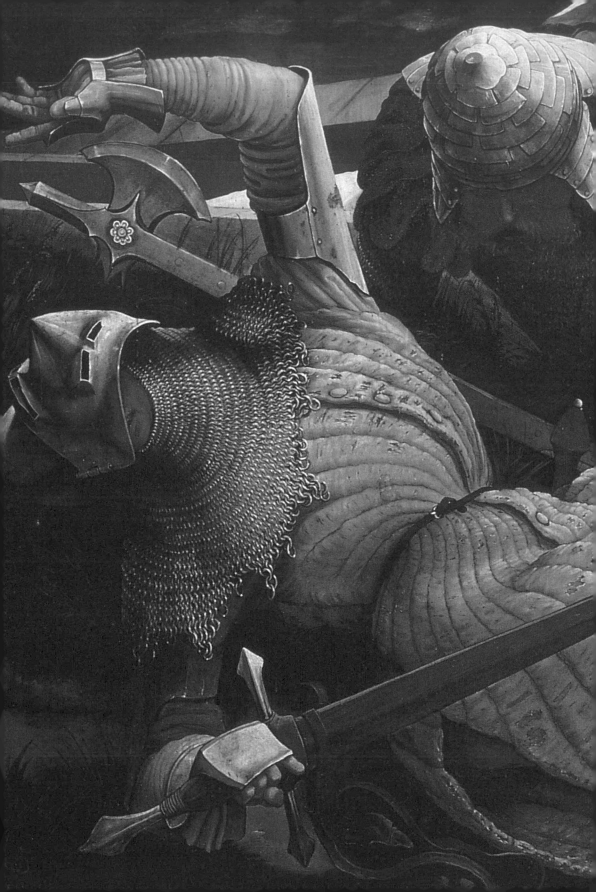

wounded soldier, sword lowered in defeat, falling forward into the shadows. This paradox, supported by the notion that many heroes die for their cause, may not have been lost on Johns—who, however, at least in his public remarks, tends to understate the possible meanings of his work. "The problem with ideas," he has said, "is, the idea is often simply a way to focus your interest in making a work. . . . A function of the work is not to express the idea."[13] Considered in nonsymbolic terms, then, the soldiers can be read as generic subjects through which to investigate the formal elements of structure and composition and to reflect on the relationship between execution and perception. Their removal from their original context serves to deny any narrative associations; by tracing them, Johns also refutes their corporal volume and depth. By repeating, flipping, or concealing the pair (as in the etching *Untitled* [1992]; fig. 4), by adding color in a patternlike fashion (as in the lithograph *Untitled* [1994]; fig. 5), and by working serially, continually reinterpreting the motif from print to print and from painting to painting, he investigates how a defined detail can be abstracted: "What seems literal can twist or be twisted into something else—as rigidly literal works tend to become transcendental."[14]

For seventeen years, this pair of soldiers remained a secondary subject in Johns's paintings and prints. In *Untitled* (1999), they emerge as the main compositional focus. The motif here is markedly similar to that of *Untitled*, from *The Geldzahler Portfolio* (1998; fig. 6); the earlier print, however, includes the floor plan of a house, which obscures and distracts from the image of the soldiers.[15] In *Untitled* (1999), Johns directly investigates issues of perception and the relationships among the figures and the ground of the printed sheet. At first glance, the viewer is immediately confronted by a shifting perspective involving the overall printed image and a trompe l'oeil sheet of paper apparently taped slightly within the print's borders—an illusion reinforced through the interplay of etched additions and subtractions. Illusion is further extended by

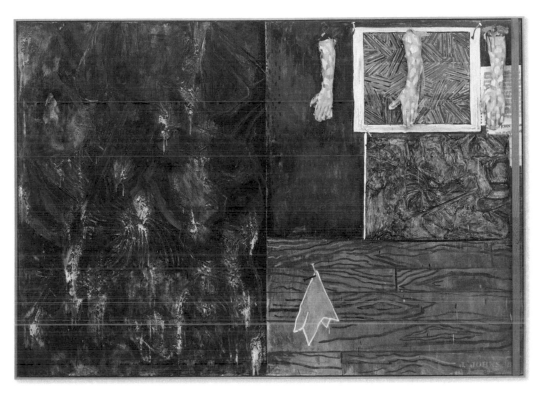

Fig. 3
Jasper Johns, *Perilous Night,* 1982
Encaustic on canvas with objects, 67 ⅛ × 96 ⅛ × 6 ¼ in. (170.5 × 244.2 × 15.9 cm)
National Gallery of Art, Washington, D.C., Robert and Jane Meyerhoff Collection

Johns's color, which seemingly exists in a realm between the etched line and the masking effects of the black aquatint ground.

Johns's tracing includes only the bottom third of the *Resurrection* panel (fig. 2): the helmet, shoulders, arms, and axe of the soldier who sits hunched over; a segment of the cloth in which Christ was wrapped; the corner edges of Christ's tomb; and the foot, sword, helmet, and raised hand of the supine soldier. This motif appears three times in *Untitled* (1999).[16] The first time it is reversed and fills the entire image (henceforth referred to as the bottom tracing; fig. 7). Obscuring this image is the trompe l'oeil dog-eared sheet of paper, which contains the same image as the bottom tracing (henceforth referred to as the top tracing; see cats. 6a–b).[17] The motif's third appearance—in which it is reversed—is in the upper-left corner, where Johns has etched another tracing of the supine soldier's sword, and along the top, where his helmet and the tips of his fingers are shown above the edge of the trompe l'oeil sheet (fig. 8). This third image (henceforth referred to as the middle tracing) is not a mirror image but is fragmented and includes only the soldier's upper body.[18] Since these repeated impressions of the main motif cannot logically exist in space, they confound our perceptions of figure and ground. Johns's reversals and replications challenge not only the limitations of two-dimensional depiction but also the viewer's ability to discern the multiple layers of imagery.

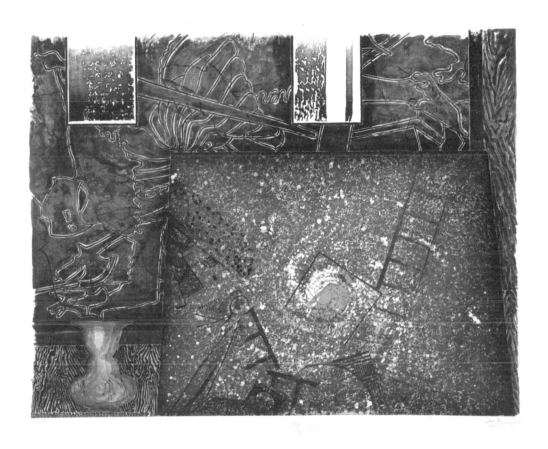

Fig. 4.
Jasper Johns, *Untitled*, 1992
Etching and aquatint, 35 ¾ × 45 ½ in. (90.8 × 115.6) (plate)
Walker Art Center, Minneapolis, Minn., Gift of the artist, 1992

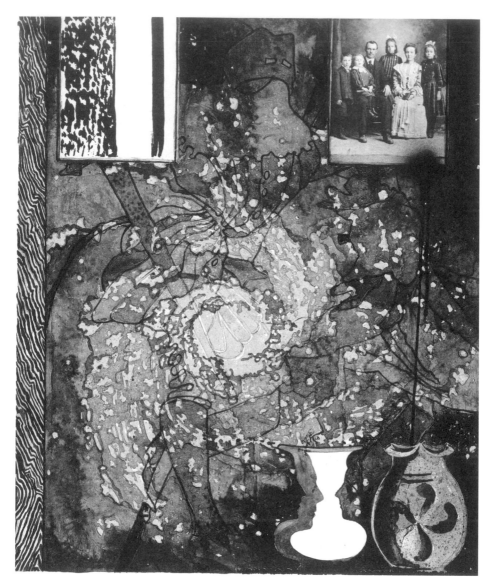

Fig. 5.
Jasper Johns, *Untitled*, 1994
Lithograph, 29 ½ × 24 ½ in. (74.9 × 62.2 cm) (stone)
Walker Art Center, Minneapolis, Minn., Gift of the artist, 1994

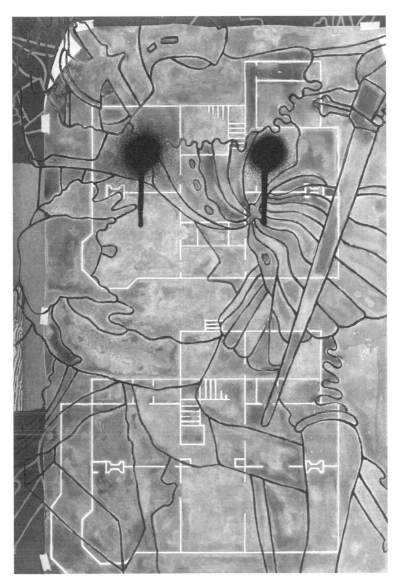

Fig. 6.

Jasper Johns, *Untitled*, from *The Geldzahler Portfolio*, 1998

Etching and aquatint, 17 × 11 ⅞ in. (45.1 × 30.2 cm) (plate)

Purchased with gifts from Catherine Cahill and William Bernhard,

B.A. 1954, and Arthur Fleischer, Jr., B.A. 1953, LL.B. 1958, and with the

Katharine Ordway Fund. 1999.6.1.5

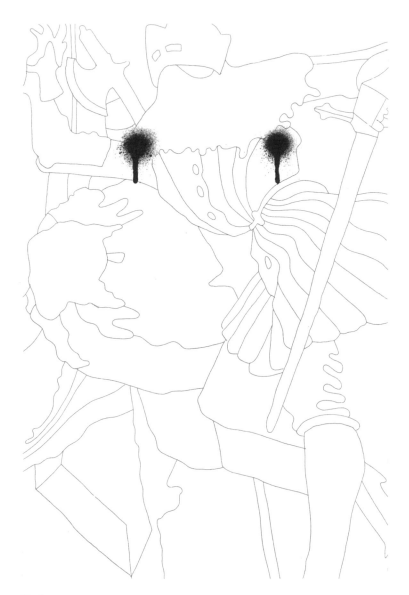

Fig. 7.
Detail of the second-state proof (cat. 3) of *Untitled*, 1999, digitally
altered to show only the bottom tracing

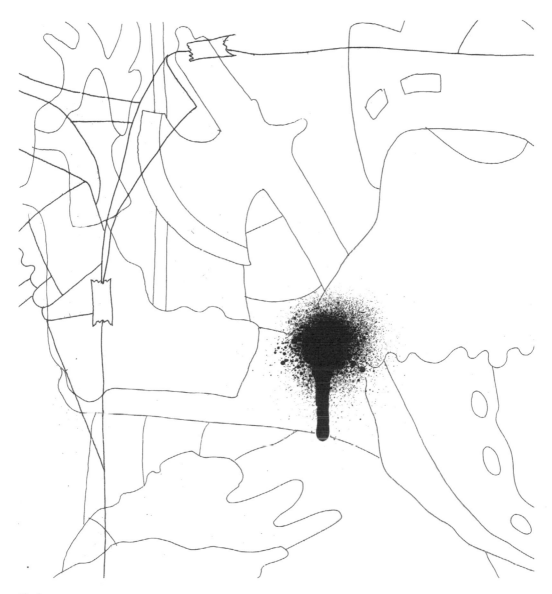

Fig. 8.
Detail of the third-state proof (cat. 4) of *Untitled*, 1999,
showing the middle tracing

The Key-Plate Design
(The State Proofs)

Untitled (1999) was printed from five plates: four color plates (blue, orange, yellow, and red; cats. 37–40) and a black (or key) plate (cat. 41). The key plate carries the fully conceived line drawing and is the plate that Johns manipulated the most in the process of creating the print; the color plates carry additional information concerning tone and color. In creating Untitled (1999), Johns considered composition, color, and tone simultaneously; for the purposes of this essay, however, the making of Untitled (1999) will be examined in a linear fashion, beginning with the key-plate design.

Johns began by recycling a rejected plate from Untitled (1998) on which he had simply etched two drip marks.[19] At each revision to this key plate, a state proof was pulled, documenting the information on the plate and resulting in a total of twelve state proofs. The first-state proof (cat. 2) of Untitled (1999) was therefore the (discarded) first-state proof for Untitled (1998). The drip marks appear here in green and red because the plate had been inked that way for Untitled (1998); these colors, however, have no bearing on the creation of Untitled (1999) but simply document the state of the plate when Johns began the work. The spray-paint-like quality of the two drip marks, enhanced by the realistic pull of gravity on the wet ink, was achieved by applying a sugar-lift aquatint.[20] Johns often uses this process because the viscous sugar solution allows him to think in positive terms, drawing directly on the plate.[21]

In the second state (cat. 3, opposite), after having decided to reuse the plate from Untitled (1998), Johns made a drawing to scale of what we are calling the bottom tracing of the Grünewald Resurrection panel. Using tracing paper, this drawing was transferred to the copper plate and then etched.[22] Some elements of the supine soldier, including his sword and armor, are clearly discernible; his gloved hand in the upper-left corner (see fig. 7), however, is transformed into pattern and arabesque line, as is the outline of the kneeling soldier. This second-state proof doubles as the first working proof, a test proof on which the artist

Detail of the second-state proof (and first working proof) (cat. 3)

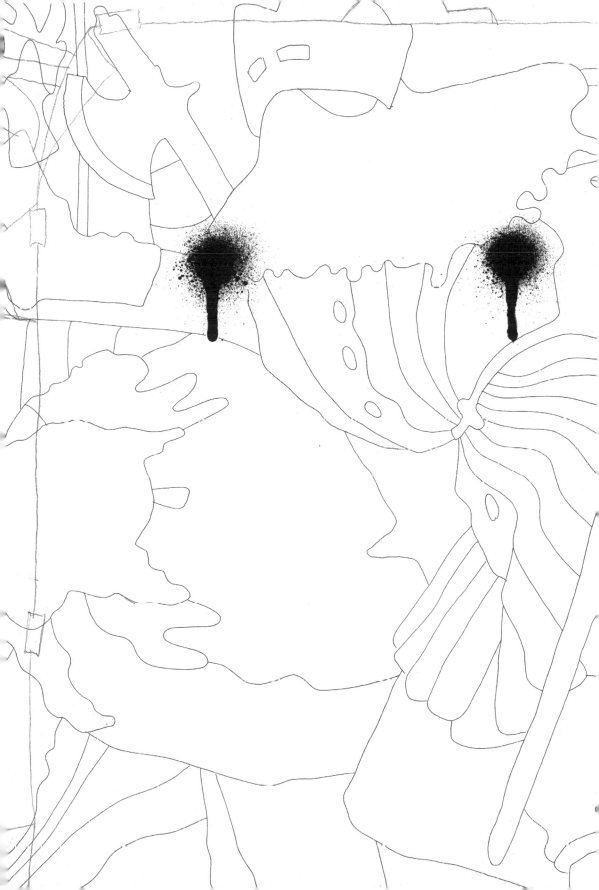

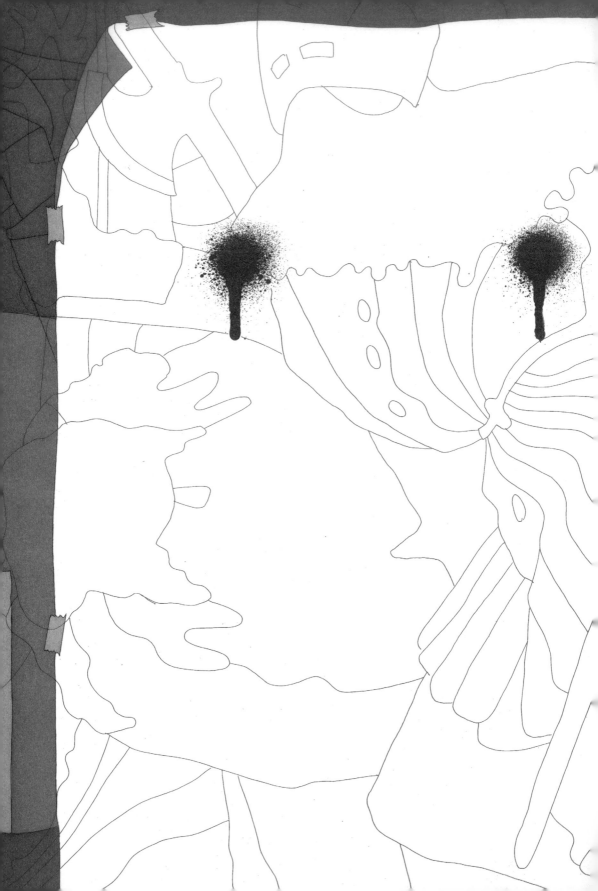

indicates revisions and changes in pen, graphite, or another medium in order to visualize the next process.[23] By drawing in blue ink over the proof, Johns indicated where he wanted to situate the edge of the "taped" sheet, as well as the sword and helmet of the supine soldier in what would become the middle tracing. Included in this overdrawing, at the bottom-left edge of the sheet, is a mirror image of the supine soldier's heel that appears at the bottom-right edge of the sheet, but this would not be carried through in the etching process (cf. cats. 3–4). Johns has repeatedly explored the pairing of opposites in his prints,[24] and in the second state of Untitled (1999), having etched one image of the pair of soldiers, he then drew the reverse image on the same proof. In this second state, he also drew an outline of what would become the patch of simulated wood grain at the center-left edge. Working in graphite, he drew a border just within the edge of the plate, clearly defining the size of the image. The artist's choice of pen or graphite for these lines indicates how he wanted the lines to be etched: as the viewer will see in the subsequent proofs, the pen additions signal darker, more deeply etched lines, while the graphite additions signal more lightly etched ones. These marks would be etched in two separate, successive stages, resulting in the third and fourth states respectively (cats. 4–5).

As far back as 1969, Johns recognized that an etched line can take on "the quality of a seismograph," an extremely sensitive register, and commented that although the surprises that can happen in the etching process can be fascinating, "none of those things are what one has in mind."[25] Here, however, Johns retained absolute control over the different strengths of his lines, skillfully exploiting their qualities. By the fourth state in the creation of Untitled (1999), he had clearly defined four distinct intensities of line, with varying degrees of depth and width: the light border, the drawing of the tracing from the Resurrection panel, the trompe l'oeil additions, and the two drips—each has a separate linear character. This was the beginning of a "layering" process (since all marks

were made in one plate, Johns was not actually layering but creating the illusion of layers). He etched the trompe l'oeil sheet slightly off-center, for instance, but in such a way that the bottom and top tracings are continuous with each other.

In the fifth state of the key-plate design (cats. 6a–b), Johns applied aquatint to produce three gradations of tone ("stopping out" the effects of the acid in three stages) along the left and top borders of the image. This application strengthened the trompe l'oeil effect of the "taped" sheet (and thereby emphasized the top tracing) by exploiting the qualities of optical perception: since the eye understands darker images as farther away than lighter ones, the bottom tracing (the darkest section of the print) is now believably "underneath" the "taped" sheet. In the sixth state (cat. 7, opposite), Johns applied an overall aquatint by using the "slosh-bite" process, in which one end of the plate (rather than the entire plate) is placed in the acid bath and then "sloshed" back and forth. The result is a tonal top-to-bottom gradation of light to dark. In the seventh state (cat. 8), he burnished (or reduced) areas of the aquatint, rubbing the plate's raised metal surface to smooth out and clarify this tonal gradation.

Throughout the making of the print, Johns's manipulation of the plate alternately concealed and revealed his imagery. In the second through fourth states, for example, he clearly etched the bottom tracing and then moved toward concealing it with the top tracing. In the sixth and seventh states, as we have seen, he boldly covered the entire image with the overall aquatint and then began to reveal it again, though transformed, through burnishing.

At this stage in the development of Untitled (1999), Johns introduced color. In the second working proof (cat. 14), we can glimpse his initial color scheme and his method of dividing color into unique registers to further abstract the tracing of the two soldiers.[26] (At this point, he applied watercolor by hand to the top tracing only; perhaps this suggests that he was thinking through ways of using color to further distinguish the top tracing from the middle and bottom ones.) He

also used color pencil to speckle the top tracing with dots, a patterning that he would transfer to the key plate in the eighth state (cats. 9a–b) through a staccato use of drypoint. This was a bold move; although its effects would become less apparent with each printing of the plate, the process could not be reversed with burnishing, since the drypoint needle pushes up a kind of collar of copper that cannot be fully smoothed away. Also in the eighth state, in addition to this stippling, the plate was further burnished along the midsection, continuing the evening out of the aquatint gradation from light to dark that had been begun in the seventh state. The eighth state of the plate was proofed twice, first in blue ink and then in black, in order to visualize how the tonal qualities of the key plate would affect the underlying colors when all five plates were printed. The blue and black inks have varying degrees of saturation and pigment density: in the black proof the gradated aquatint moves from deep black to gray, while in the blue proof the color appears brighter and more ethereal.

In the ninth state (cat. 10, opposite), Johns employed the process known as spit bite to yield a watercolor-like effect along the sword and in areas of the soldier's armor, both darkening those areas and strengthening the outline of the tracing.[27] He also etched the simulated wood grain on the patch at the center-left side of the image.[28] Although it had been clear since the second state that Johns intended to include this patch of wood grain, he waited until the ninth state to realize it fully. Johns's paintings and prints are often concerned with time and memory. This is particularly evident when he capitalizes on inherent elements of the printing process:

> Working with this medium is interesting because it has to do in part
> with time: whether you think of something before or whether you
> think of it after, whether you do something that shows or whether
> you do something that doesn't show when you did it or how you did

it. It's very different from painting or drawing, in which everything
on the surface can at any moment be changed. When something is
printed, it has to be done in an order. You have to consider how it can
be printed, and how it will be printed.[29]

Johns had intended to add the wood grain from the start, but by waiting he left
open the possibility of alternate interactions with other parts of the motif.

In the tenth state (cat. 11), Johns reapplied an aquatint, this time achieving
a softer tonality than the previous application.[30] This application also negated
much of the effect of the marks made in the preceding two states. In the elev-
enth state (cat. 12, opposite), Johns resolved how to embolden the top tracing:
he used the sugar-lift process to trace over the more lightly etched lines of the
tracing, augmenting their volume and weight and further distinguishing the top
tracing from the bottom one. By examining the third working proof (cat. 15), we
can deduce that Johns's preference for the dark outline was generated by a con-
current decision to apply color to the entire print. Tone and color as well as line
would be used to distinguish the two tracings.

Only a few adjustments, albeit significant ones, were made in the twelfth
and final state (cat. 13) to complete the key-plate design. At the corners of the
dog-eared sheet and on the simulated pieces of tape, Johns burnished the plate,
removing the aquatint to expose the simple etched line of the tracing. Johns
used his burnisher as a drawing implement; however, rather than effacing his
marks, he revealed the history of what was there, transforming the copper plate
into a palimpsest.[31] Here, the design continues beyond the confines of the sheet,
reflecting the way Johns executed the plate as one flat design (the bottom trac-
ing) before imposing the trompe l'oeil sheet.[32] The dog-eared corners are "bent"
at such an angle that the motif on the front side lines up with the drawing that
seemingly comes through from the back.[33]

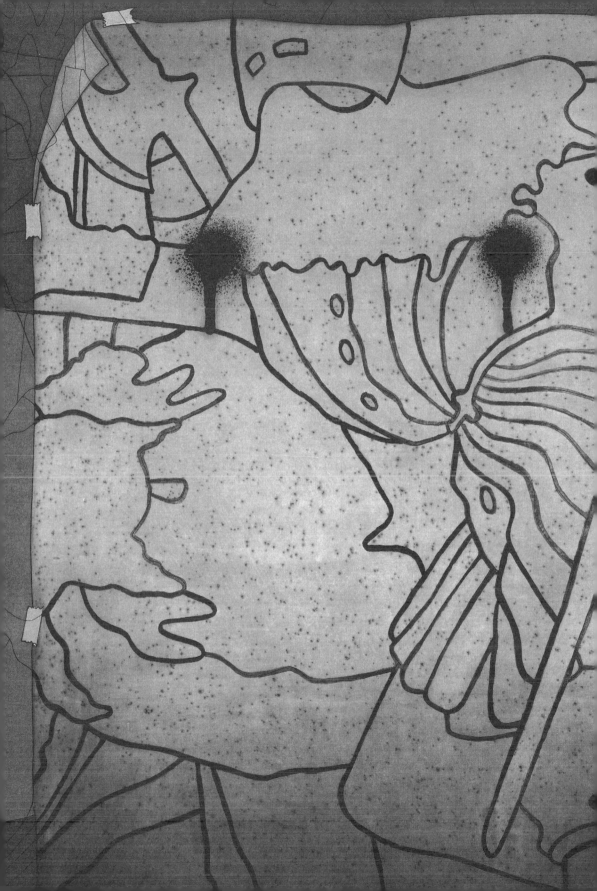

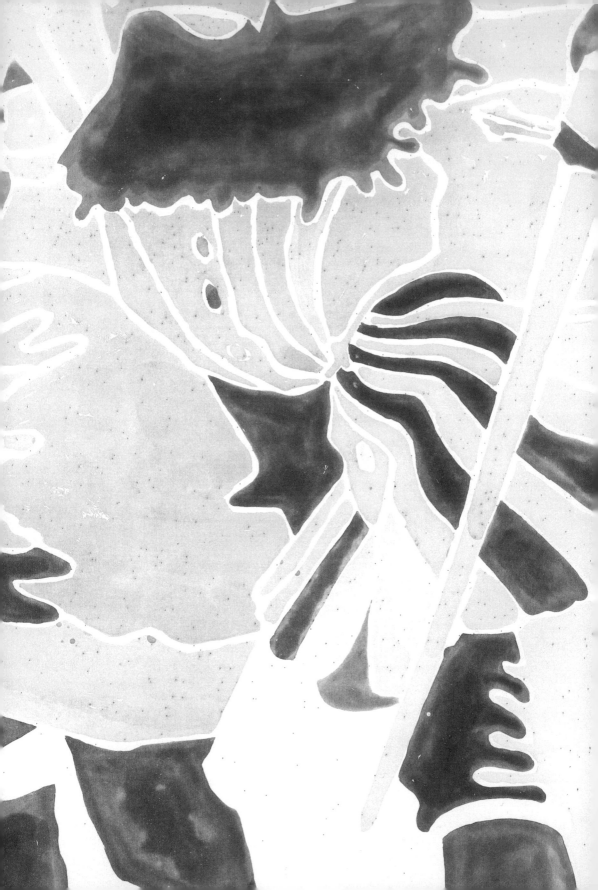

The Elements and Progressives

In printmaking, it is traditional for a separate plate to be used for each color. In addition to the black key plate (cat. 41) discussed earlier, four color plates—blue, orange, yellow, and red (cats. 37–40)—were created and used to make *Untitled* (1999).[34] The proofs printed from these five plates are referred to as "elements" (cats. 27–31, see opposite). By examining the working proofs we can ascertain how Johns arrived at these colors and their arrangement. Returning to the second working proof (cat. 14), we notice that, rather than using color to distinguish the features of the soldiers (by coloring the skirt of the supine soldier's armor in one consistent color, say, as Grünewald did), Johns interspersed colors without an obvious scheme, although he was clearly thinking in terms of patterning.[35] The effect was to distort the figures' forms, obscuring the possible allusion to its original source—the *Isenheim Altarpiece*.

At the same time that Johns was resolving how to allocate areas of color, he was considering color choice. He often thinks of color in terms of primaries and secondaries, viewing the two, according to Lund, "as opposite sides of the same card."[36] *Untitled* (1999) is no exception. In the second working proof, Johns loosely painted watered-down washes of the primary colors red, yellow, and blue over the top tracing. In certain areas, he blended yellow and blue to create green, the complementary color to red. In the third working proof (cat. 15), he applied to the entire image intense watercolor hues of the secondary colors orange, green, and violet, as well as the primary color blue (the complementary color to orange). By comparing the second and third working proofs (cats. 14–15), we witness the systematic nature of his approach to color, setting primaries against secondaries and coupling complementary pigments. Below the platemark of the third working proof, Johns wrote the following instructions: orange-orange; green-blue; violet-red; and blue-yellow. In certain areas of the print, he wrote the letters *G* (in the center of the supine soldier's skirt, for instance, and in the handle of his sword) and *V* (in the supine soldier's second breast button),

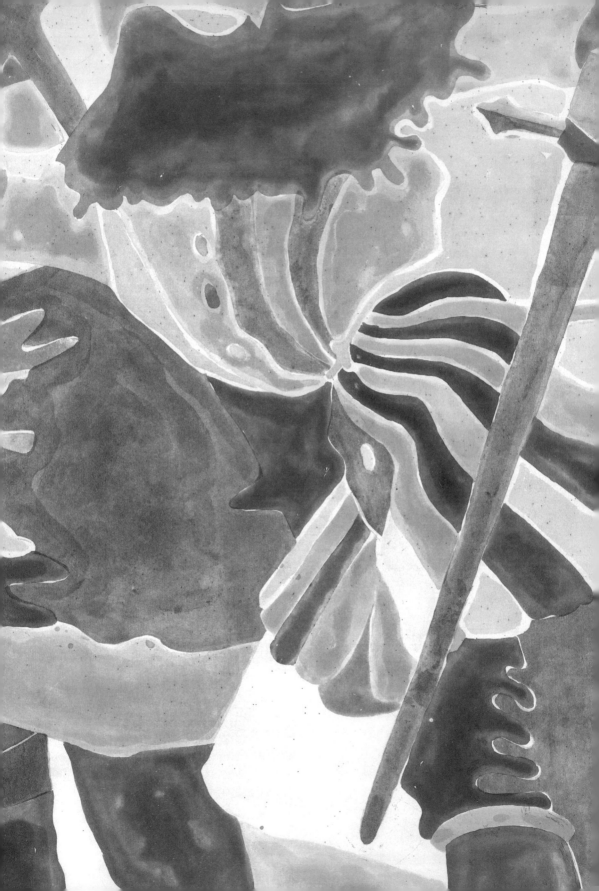

indicating that these areas should be treated as the color designated by the letter, in these cases green and violet. Thus, when he implemented the changes indicated below the platemark, the area marked *V* became red. By the time he created this proof, then, Johns had fully conceived how he would divide color into registers, and what colors he would use: the primary colors red, yellow, and blue and the secondary color orange.

In the second and third working proofs, color was applied by hand, using watercolor washes over a proof of the key plate. In the fourth and final working proof (cat. 16), color was added by printing all four color plates as well as the key plate. Johns's only hand additions here were in brown watercolor along the supine soldier's sword and helmet. By the eighth state in the development of the key plate, then, it is clear that Johns had almost fully etched all four color plates.

Since the key plate in *Untitled* (1999) contained an overall aquatint and was the final plate printed, it modified the value (the lightness or darkness) and intensity (the brightness or dullness) of the colors when it was printed over them. This is demonstrated in the five "progressive proofs" (cats. 32–36)—proofs made to provide a sequential record of the final printing. From the first to the fourth progressive, there is very little interaction between the color plates. In the fourth progressive (cat. 35, opposite), the colors boast a bright intensity and intermediate value. When the black key plate is added, the colors are toned down and darkened.

The Trial Proofs

Johns began to pull "trial proofs," or test impressions, at the eighth state of the key plate. There are ten of these proofs altogether (cats. 17–26), and in examining them we see Johns balancing color and tonality—moving back and forth among ink choices for the key plate and varying the hue and intensity of the colors to achieve the effect he desired. In each of the trial proofs, all five plates—the four color plates and the key plate—were printed on one sheet, in the sequence blue, orange, yellow, red, and the key plate. In printing the key plate, Johns experimented with different colors—blues, browns, and blacks. In the first trial proof (cat. 17, opposite), the key plate, which was in the eighth state, was inked in blue. In the second and third trial proofs (from the eighth and ninth states of the key plate respectively; cats. 18–19), the key plate was printed in brown. Comparison of these early trial proofs clarifies how the overall application of an aquatint to the key plate alters the intensity and hue of the color plates. When the key plate is printed in blue ink, the red and yellow are intensified; when it is printed in brown, the colors, especially the orange and red, grow warmer and more subtle.

Although the key plate was inked in brown for both the second and third trial proofs, the overall tone of these proofs varies. This is explained by subtle changes made to the red plate. For the printing of the second trial proof (cat. 18), Johns altered the red plate by stippling with a drypoint needle, creating an effect similar to that on the key plate. Then, in the third trial proof (cat. 19), he added a very light aquatint to the red plate, which, when overprinted in brown from the key plate, yielded a warmer undertone without darkening the color.

In these early trial proofs, Johns seems to have preferred the warmer tones produced by printing the key plate in brown ink. With subsequent alterations of the key plate (that is, in the ninth and tenth states), Johns varied the aquatint

Detail of the first trial proof (cat. 17)

ground, subtly modifying the overall effects of color and transparency. By the eleventh state of the key plate (cat. 12), however, when the sugar-lift emboldened the top tracing, Johns's preference for printing the key plate in black was clearly established.[37] Between the sixth and tenth trial proofs (cats. 22–26), he only printed the key plate in brown once (in the eighth trial proof; cat. 24). When the sixth trial proof was pulled, the key plate was in the eleventh state, and only subtle revisions were made at the twelfth state. In these later trial proofs, Johns focused on adjusting the intensity of the pigments, starting with a very light tone in the sixth trial proof and progressively moving to a darker, more intense use of color by the tenth trial proof. By the tenth and final trial proof, all five plates had been fully etched, and thus essentially ready to be printed and editioned.[38]

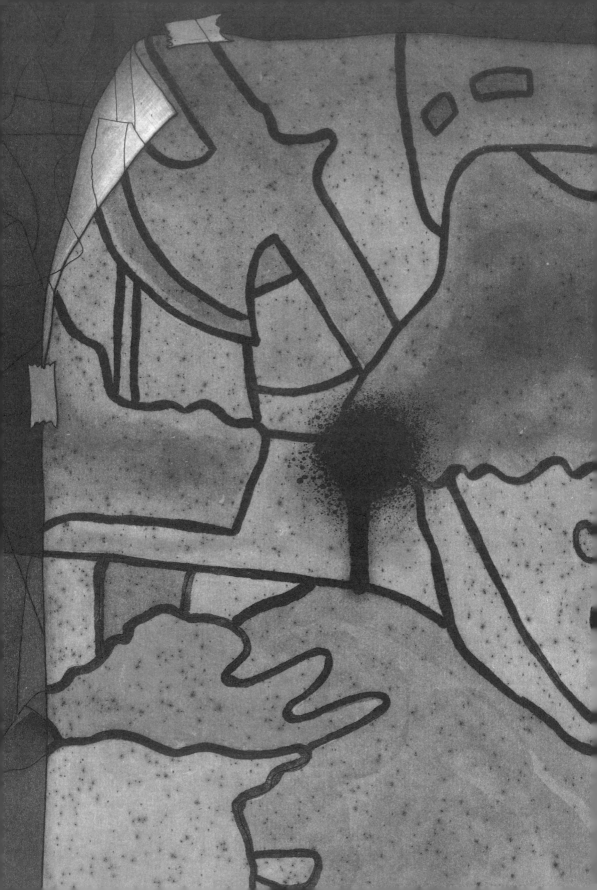

Conclusion

Having honed his knowledge of etching processes over the past forty-six years, Jasper Johns is keenly aware of the intrinsic properties of intaglio and brings this knowledge to each project, capitalizing on the medium's attributes in playful ways. *Untitled* (1999) is no exception.

In *Untitled* (1999), as so often in his work, Johns does not disguise the fact that in looking at an image we are looking at a flat surface. One of his first marks on the key plate was a border around the image, signaling a defined shape and size with nothing beyond. The border also draws attention to the platemark, another reminder that this is a printed image. Yet Johns then counters this assertion of flatness, and challenges our perceptions, by crafting the illusion of multiple, layered sheets of paper, with the final layer folding out three-dimensionally, confronting and invading our space.

These layers assume a new dimensionality when we recall that an etching, as witnessed in the creation of *Untitled* (1999), is carried out in stages. The bottom tracing in *Untitled* (1999) is a previous state of the top tracing, minus the emboldened overdrawing. On a similar note, Johns initially outlined the soldier figures by tracing a reproduction of Grünewald's *Resurrection* panel. By layering one such tracing over another in the print, he demonstrates and reminds us of this process, and allows us to envision him at work. This is also where his playfulness emerges: *Untitled* (1999) is an etching whose composition consists of a drawing, reversed by the etching process, derived from a tracing of a reproduction of a painting. This tracing is apparently taped over two other drawings of the same image, one in a comparable orientation, the other in reverse.

Just as Johns reminds us of the origin of the tracings, he further challenges what we perceive and what we remember through his use of color and his inclusion of the two black drip marks. His color palette of blue, orange, yellow, red, and black in *Untitled* (1999) is reminiscent of Grünewald's *Resurrection* panel. Furthermore, the masking effect created by the gradated aquatint

Detail of *Untitled*, 1999 (cat. 1)

ground, coupled with the intense color palette, recalls the dramatic vision in the *Resurrection* panel in which Christ gloriously rises out of the tomb, his yellow aura illuminating the night sky. If perceived in this manner, the two drip marks in Johns's etching may in fact allude, as Richard Field has suggested, to Christ's stigmata.[39] As with the many layers of tracings in *Untitled* (1999) that evoke previous states of the image, here Johns ultimately suggests the initial work that preceded them all.

Notes

1 The following publications focus on Jasper Johns's printmaking process: Richard S.
 Field, *Jasper Johns: Prints, 1960–1970* (New York: Praeger, and Philadelphia: Philadelphia
 Museum of Art, 1970); Roberta Bernstein, *Jasper Johns Decoy: The Print and the Painting*
 (Hempstead, N.Y.: The Emily Lowe Gallery, Hofstra University, 1972); Field, *Jasper Johns:
 Prints, 1970–1977* (Middletown, Conn.: Wesleyan University, 1978); Christian Geelhaar,
 Jasper Johns: Working Proofs (London: Petersburg Press, 1980); Judith Goldman, *Jasper Johns:
 Prints, 1977–1981* (Boston: Thomas Segal Gallery, 1981); Riva Castleman, *Jasper Johns: A Print
 Retrospective* (New York: The Museum of Modern Art, 1986); *Jasper Johns: Printed Symbols*
 (Minneapolis: Walker Art Center, 1990); *The Prints of Jasper Johns, 1960–1993: A Catalogue
 Raisonné*, with text by Field (New York: Universal Limited Art Editions, 1994); Wendy
 Weitman, *Jasper Johns: Process and Printmaking* (New York: The Museum of Modern Art,
 1996); and, most recently, Joan Rothfuss, *Past Things and Present: Jasper Johns since 1983*
 (Minneapolis: Walker Art Center, 2003).
2 Johns, quoted in Geelhaar, *Jasper Johns: Working Proofs*, 39.
3 John Lund studied printmaking with Zigmonds Priede at the University of Minnesota. He
 initially worked as a lithograph printer at ULAE, then took a leave of absence to direct
 the etching department of the Burston Graphic Center in Jerusalem, Israel. In 1978 he
 returned to ULAE to restart the etching department. He first worked with Johns in 1972
 and 1973, assisting him on *Cups 4 Picasso* and *Cups 2 Picasso*; in 1987 and 1989, he was the
 master printer on the *Seasons*. Although Johns began the *Seasons* at ULAE's press in Long
 Island, for much of the project he and Lund worked at ULAE's offsite press on Watt
 Street in TriBeCa (active from 1985 to 1995). It was during this period that Johns began to
 consider the idea of building his own print workshop, perhaps due to the proximity of
 the Watt Street studio to his current residence.
4 Lund, interview with the author, July 7, 2005.
5 To avoid occupying the Low Road Studio with production, Johns often sends the plates
 he creates there to ULAE or another press to be editioned. In the ten years since the
 studio opened, he has produced approximately twelve prints under the Low Road
 imprint alone. One of these is the subject of the present essay, *Untitled* (1999).
6 Along with engraving and aquatint, etching is an intaglio method. All intaglio printing
 involves forcing ink into incised lines on a metal plate. The image is made by inking
 the plate, wiping the surface so that only the incised lines retain the ink, placing damp
 paper over the plate, and running it through a roller press.
 To make an etching, a metal plate, usually copper, is covered with an acid-
 resistant ground. Using a sharp needle, the artist cuts through this ground to uncover
 areas of the plate, which is then exposed to acid, incising those areas left bare. The

longer the acid is allowed to bite, or corrode, the copper, the deeper and broader the line and the darker it will print. The flat surface of the plate can also be manipulated without the use of acid by engraving techniques such as employing a drypoint needle or a burnishing tool (used to reduce or erase marks). When the plate is inked and placed in a roller press, the pressure pushes the ink out of the incised lines and onto the paper.

7 Although printmaking workshops such as ULAE or Gemini G.E.L. may accumulate working proofs for a particular project, they by no means maintain a complete archive. Moreover, the plates or stones are traditionally destroyed once the production of the edition is complete. Johns is the rare artist who often preserves his plates and stones for future consideration. For *Untitled* (1999), however, Johns discretely etched an X in the upper-right corner of each plate, signaling that the plates will no longer be considered for future use.

8 In addition to the final print, the archive for *Untitled* (1999) contains five copper plates; fourteen key-plate proofs representing twelve states (both the fifth and eighth state were proofed twice; the second key-plate proof doubles as the first working proof); three (additional) working proofs; eleven trial proofs (the tenth and final proof was pulled twice); nine elements (five pulled from the plates printed in their respective colors— blue, orange, yellow, red, and black—and four pulled from the color plates printed in black); and four progressive proofs. The elements printed in black from the blue, orange, yellow, and red color plates were completed after production and had no bearing on the creation of the print; instead, they act as a record of each plate and were printed in black because it produces a consistent and legible image.

9 Between 1508 and 1516, Abbot Guido Guersi commissioned Grünewald (1480–1528) to paint the altarpiece for the Antonite monastery at Isenheim. The monastery was devoted to the care of the sick and the altarpiece functioned as part of a program of healing through the Christian concept of salvation. See Ruth Mellinkoff, *The Devil at Isenheim: Reflections of Popular Beliefs in Grünewald's Altarpiece* (Berkeley: University of California Press, 1988), and Andrée Hayum, "The Meaning and Function of the Isenheim Altarpiece: The Hospital Context Revisited," *Art Bulletin* 59, no. 4 (December 1977): 501–17.

10 Johns, quoted in Bryan Robertson and Tim Marlow, "Jasper Johns," *Tate: The Art Magazine* (London), no. 1 (Winter 1993), reprinted in *Jasper Johns: Writings, Sketchbook Notes, Interviews,* ed. Kirk Varnedoe (New York: The Museum of Modern Art, 1996), 288.

11 The paintings include *Mirror's Edge* (1992), *Mirror's Edge II* (1993), *Untitled* (1992–94), and *Untitled* (1992–95); see Varnedoe, ed., *Jasper Johns: A Retrospective* (New York: The Museum of Modern Art), pls. 236–37 and 241–42. For the prints, see Rothfuss, *Past Things and Present,* cat. nos. 43 (*Untitled*, 1992), 45 (*Untitled*, 1992), 46 (*Untitled*, 1992), 51 (*Untitled*, 1994),

54 (*Untitled*, 1995), 62 (*Untitled*, 1997), and 64 (*Untitled*, 1998).

12 See Jill Johnston, *Jasper Johns: Privileged Information* (New York: Thames and Hudson, 1996).

13 Johns, quoted in Katrina Martin, "An Interview with Jasper Johns about Silkscreening," in *Jasper Johns: Printed Symbols*, 61.

14 Johns, Sketchbook E, ca. 1992–93, in *Writings, Sketchbook Notes, Interviews*, 76.

15 The floor plan is reconstructed from Johns's memory of the plan of his grandfather's house, which he lived in as a child. The composition of *Untitled* (1998) relates directly to a painting from 1995, now in a private collection.

16 So removed is this image from its original context that a viewer unfamiliar with Johns's appropriation of the *Isenheim Altarpiece* would be hard pressed to decipher the tracings. In the author's experience, such viewers may readily recognize the trompe l'oeil illusion of the "taped" sheet yet fail to perceive the tracings; rather, some viewers suggest that the motif includes an image of a woman in profile.

17 Johns's use of the folded-over piece of paper is linked to a poster he made for the Festival d'Automne, Paris, in 1992; see Field, *The Prints of Jasper Johns, 1960–1993*, 258. His idea for this poster came after someone had given him Piranesi's etching *Le rovine del castello dell'Acqua Giulia (The Ruins of the Castle of Acqua Giulia)* (1761): "At first glance the Piranesi seemed to represent architectural studies. Later I saw another level of representation, suggesting that the studies were on several unrolled sheets or pages. This complication, this other degree of 'reality' or 'unreality,' interested me." Johns, interview with Mark Rosenthal, 1992, in *Writings, Sketchbook Notes, Interviews*, 282.

18 By comparing *Untitled* (1998) with *Untitled* (1999), we can explore how Johns uses the same motif over and over again but works through problems and views it in a new, fresh manner. In *Untitled* (1998), Johns does not vary his etched line, so that this print's equivalent of the bottom tracing in *Untitled* (1999) sits on top of the "taped" sheet while the middle tracing clearly exists underneath. Here, Johns also includes the supine soldier's heel. Spatial relationships are also more clearly defined here than in *Untitled* (1999).

19 Lund, interview with the author, July 7, 2005.

20 In the sugar-lift aquatint process, the artist draws directly on an unprotected plate, using a mixture of sugar and water. When this solution is dry, a protective ground is applied to the surface; the plate is then washed with warm water, dissolving the area painted with sugar but leaving the rest of the protective ground. An aquatint ground is then applied to the unprotected areas of the plate.

 In the aquatint process, the plate is dusted with powdered rosin, which adheres to it inconsistently. The acid then applied to the plate attacks the areas unprotected by

rosin, which then print as a fine tone. The texture is dependent on the size of grains of rosin, while the depth of the tone changes with the length of the plate's immersion in the acid.

21 Lund, interview with the author, July 7, 2005.

22 Ibid.

23 Lund, in ibid., commented that Johns's use of working proofs is "one way for him to focus on what is possible. Working proofs are his dialogue with the medium—a kind of call-and-response dance with the copper."

24 See Field, "Introduction," in *The Prints of Jasper Johns, 1960–1993*, n.p.

25 Johns, quoted in Joseph E. Young, "Jasper Johns: An Appraisal," *Art International* 13 (September 1969): 52.

26 In the second and fourth working proofs, the key plate was printed twice, causing a slight double image. While Lund could not recall the exact reason for printing the key plate twice, he suggested that in these working proofs another state of the key plate may have been printed over the previous one to see how the etch would look. Lund, interview with the author, March 9, 2006.

27 The spit-bite technique involves painting with acid (typically, the corrosive salt called ferric chloride) directly on an aquatinted plate. Although still highly concentrated, the acid was traditionally mixed with the artist's saliva (hence the name) to prevent it from beading up on the plate.

28 The lithograph *Savarin* (1977) was Johns's first print in which the wood grain featured prominently. In his essay "Translation and Transformation in *Target with Four Faces:* The Painting, the Drawing, and the Etching," Charles W. Haxthausen argues that the wood grain is an "indexical sign of temporality" and relates to Johns's concern with the theme of the passage of time. See *Jasper Johns: Printed Symbols*, 72. Johns maintains that the simulated wood grain is not a frame but part of the back of a stretcher. See Johns, interview with Rosenthal, in *Writings, Sketchbook Notes, Interviews*, 282.

29 Johns, interview with Rosenthal, in *Writings, Sketchbook Notes, Interviews*, 281.

30 This softer tonality results from the use of very fine rosin and a lower ratio of acid.

31 Lund, interview with the author, July 7, 2005.

32 Field, unpublished notes on *Untitled* (1999), curatorial files, Department of Prints, Drawings, and Photographs, Yale University Art Gallery.

33 Perhaps the trompe l'oeil sheet is to be understood as a sheet of translucent frosted Mylar, a material Johns regularly uses, taped over another drawing (or painting or print) of a similar motif. The simulated washlike application of color on the top tracing supports this theory, while the variation in the etched line disputes it. In typical

Johnsian fashion, the final mark made to the plate remains ambiguous.

34 Each color plate was etched through the application of spit-bite aquatint to achieve a watercolor-like effect. Unlike the key plate, in which multiple changes were made, the color plates were etched in one stage. Lund, interview with the author, March 9, 2006.

35 The numeral "2" in select areas of the second working proof possibly signifies an area that will ultimately be etched onto one of the color plates, in this instance the second copper plate.

36 Lund, interview with the author, March 9, 2006. Johns used the same method in the *Cicada* prints of 1979 and 1981: "In working with the prints, I wanted to try the two other possibilities that occurred to me. One was to have the central area be the secondary colors [and] the outer edges be the primary colors on the field of white; and the reverse of that with the gray." Quoted in Martin, *Jasper Johns: Printed Symbols,* 58.

37 The sixth and seventh trial proofs are essentially from the same state of the key plate—the eleventh state. The difference is that when Johns initially applied the sugar-lift aquatint drawing over the top tracing, the new aquatint application canceled out the old, resulting in white lines in the bottom third of the print. This was corrected in the seventh trial proof.

38 Comparison of the last trial proof to the editioned print of *Untitled* (1999) may indicate otherwise, but the difference arises because, when the print was editioned, a steel-coating was applied to the copper plates. Since steel is less reactive than copper, a steel-coated surface will produce pigments more true to color than a copper one will. Pigments also bind less tightly to steel than to copper and therefore release more readily during the wiping process.

39 Field, unpublished notes on *Untitled* (1999).

The Archive of *Untitled* (1999)

The Final Print

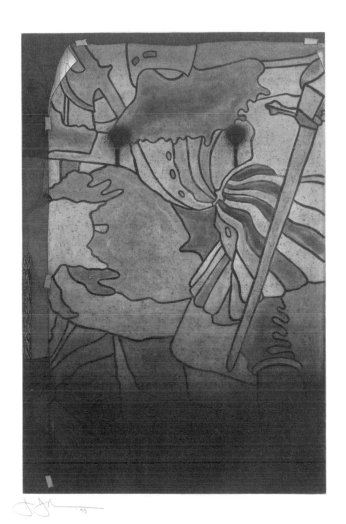

Cat. 1. *Untitled*, 1999

The Key Plate Design

trclinc proof (1st state)

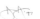

Cat. 2. First-state proof

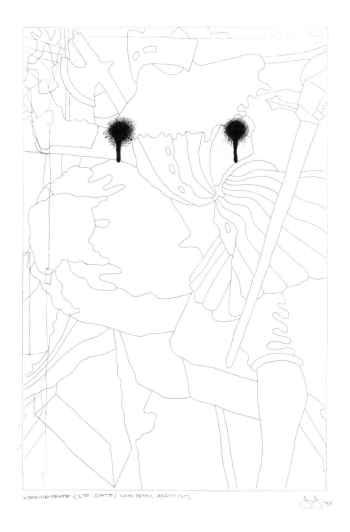

WORKING PROOF (2ND STATE) WITH PENCIL ADDITIONS

Cat. 3. Second-state proof (and first working proof)

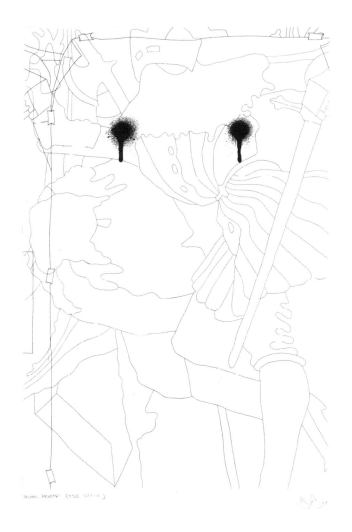

TRIAL PROOF (3RD STATE)

Cat. 4. Third-state proof

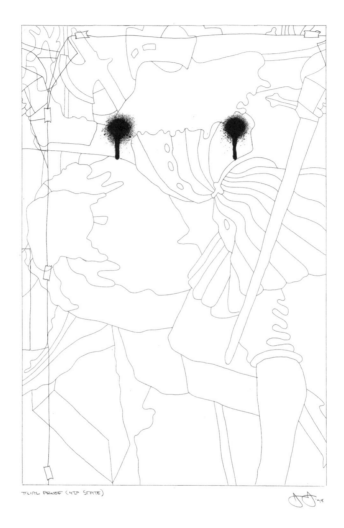

TRIAL PROOF (4TH STATE)

Cat. 5. Fourth-state proof

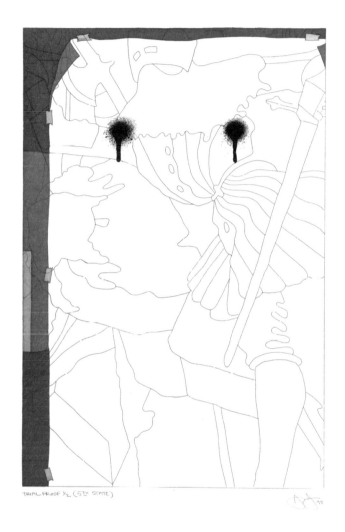

TRIAL PROOF ½ (5ᵀᴴ STATE)

Cat. 6a. Fifth-state proof, first of two

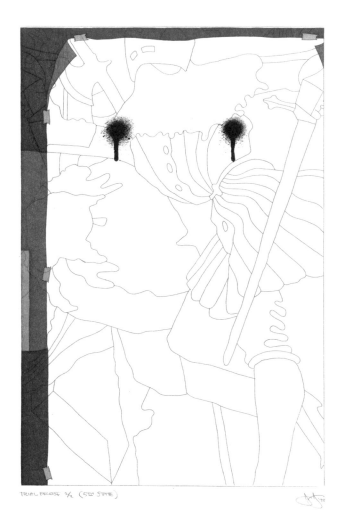

TRIAL PROOF 2/2 (5TH STATE)

Cat. 6b. Fifth-state proof, second of two

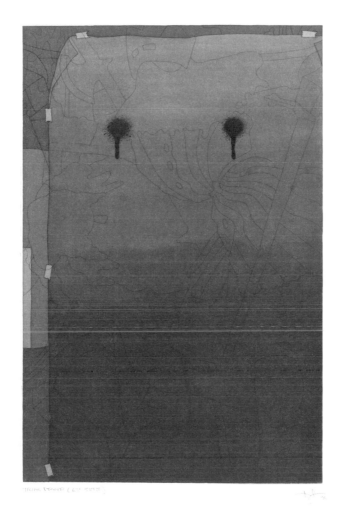

Cat. 7. Sixth-state proof

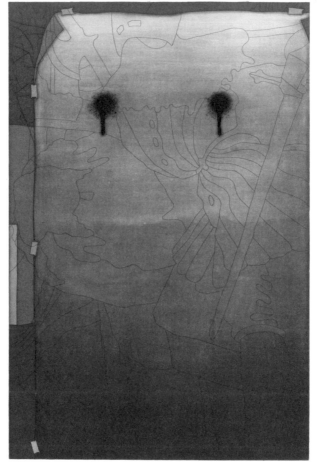

TRIAL PROOF (7TH STATE)

Cat. 8. Seventh-state proof

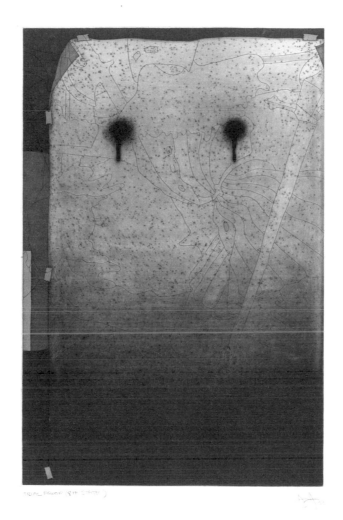

Cat. 9a. Eighth-state proof, printed in blue

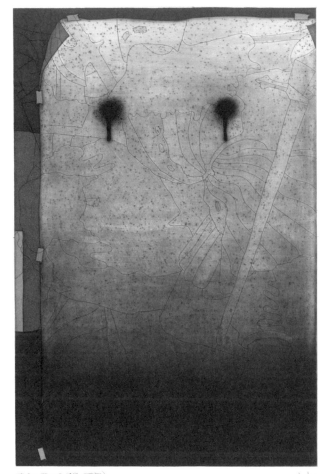

TRIAL PROOF (8TH STATE)

Cat. 9b. Eighth-state proof, printed in black

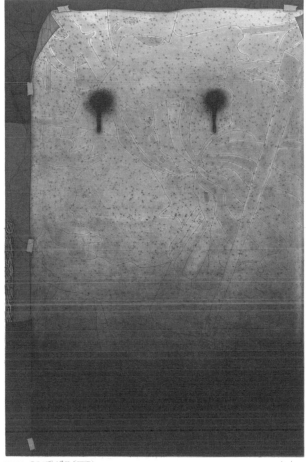

TRIAL PROOF (9ᵀᴴ STATE)

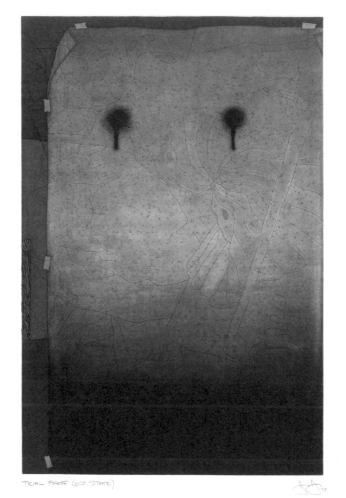

TRIAL PROOF (10ᵀᴴ STATE)

Cat. 11. Tenth-state proof

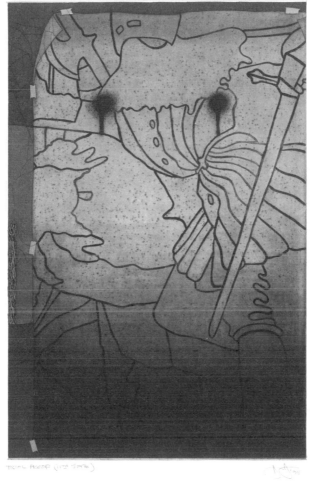

TRIAL PROOF (11TH STATE)

Cat. 12. Eleventh-state proof

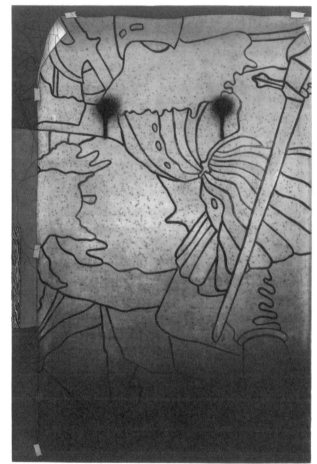

TRIAL PROOF (1ST ST)

Cat. 13. Twelfth-state proof

The Working Proofs

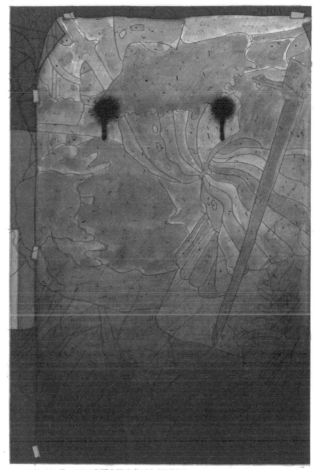

WORKING PROOF WITH WATERCOLOR + PENCIL ADDITIONS

Cat. 14. Second working proof

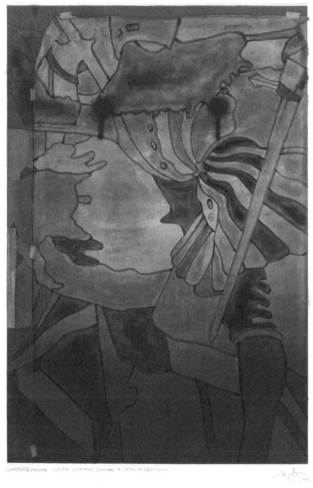

WORKING PROOF WITH WATER COLOR + INK ADDITIONS

Cat. 15. Third working proof

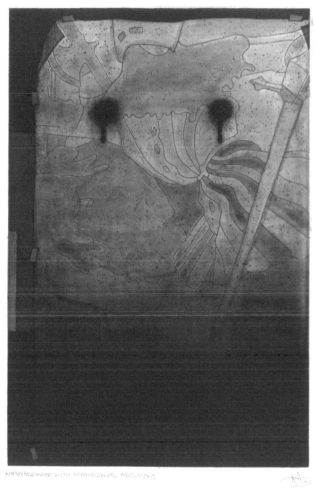

WORKING PROOF WITH WATERCOLOR ADDITIONS

Cat. 16. Fourth working proof

The Trial Proofs

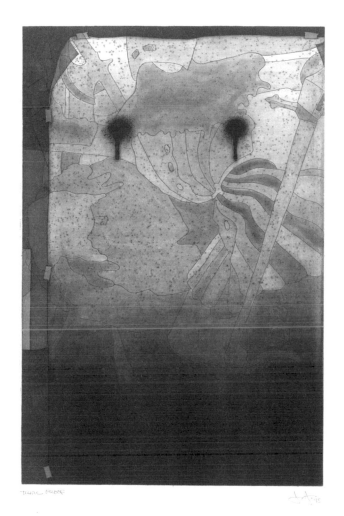

TRIAL PROOF

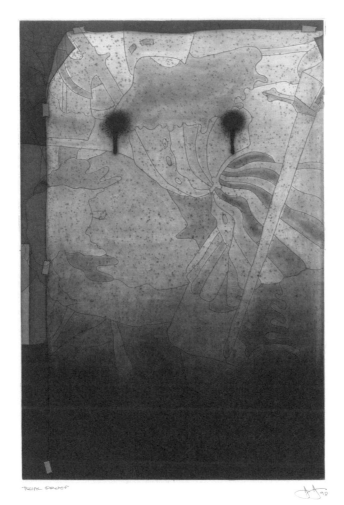

TRIAL PROOF

Cat. 18. Second trial proof

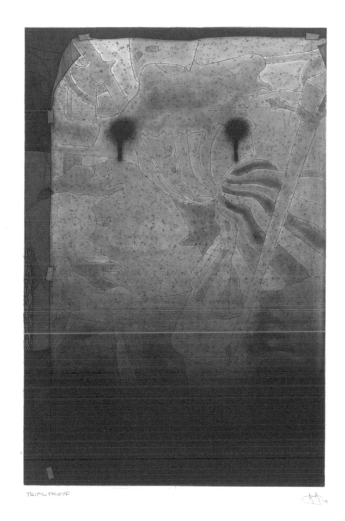

TRIAL PROOF

Cat. 19. Third trial proof

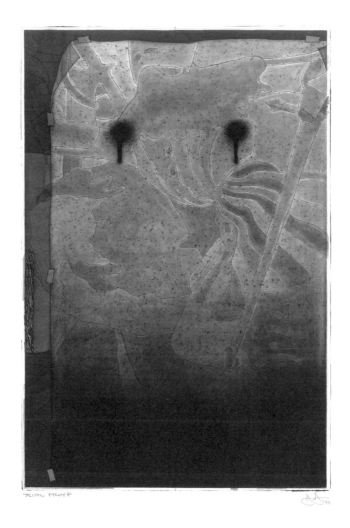

TRIAL PROOF

Cat. 20. Fourth trial proof

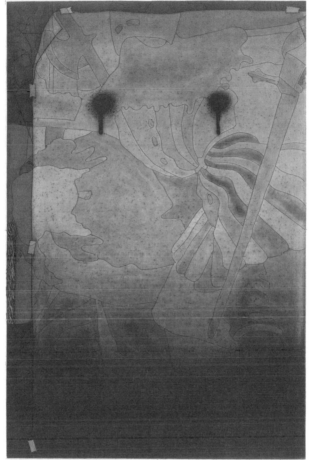

TRIAL PROOF

Cat. 21. Fifth trial proof

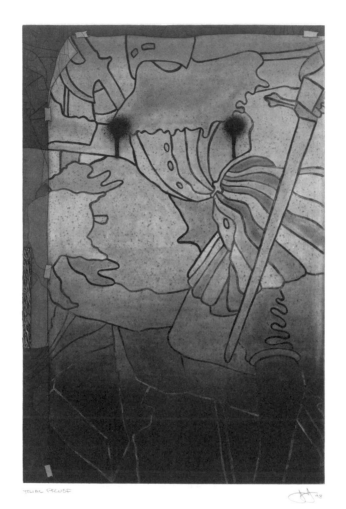

TRIAL PROOF

Cat. 22. Sixth trial proof

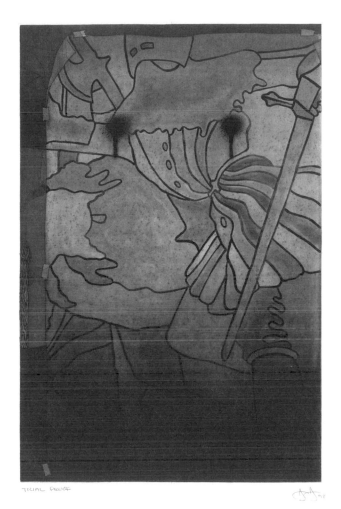

TRIAL PROOF

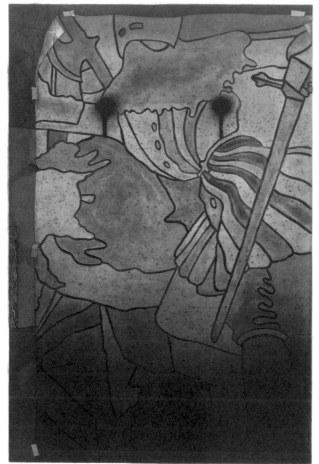

TRIAL PROOF

Cat. 24. Eighth trial proof

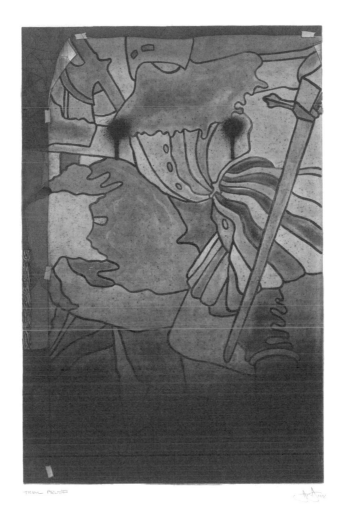

TRIAL PROOF

Cat. 25. Ninth trial proof

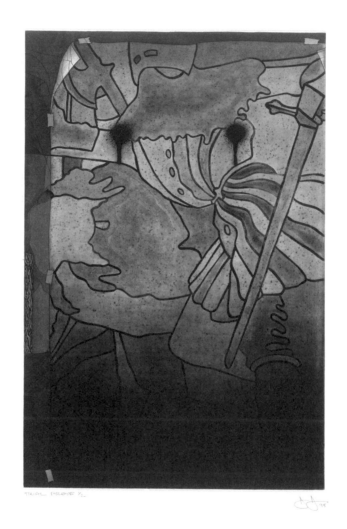

TRIAL PROOF 2/2

Cat. 26. Tenth trial proof, first of two

The Elements

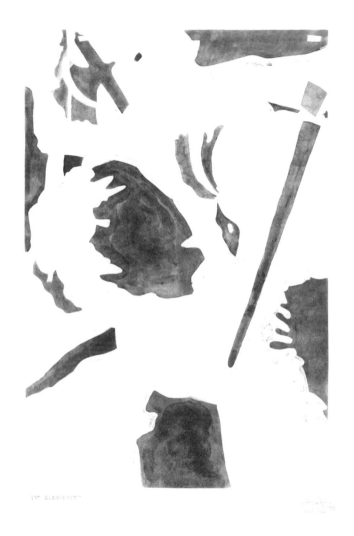

Cat. 27a. First element, printed in blue

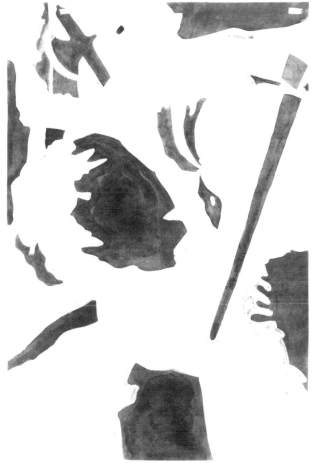

Cat. 27b. First element, printed in black

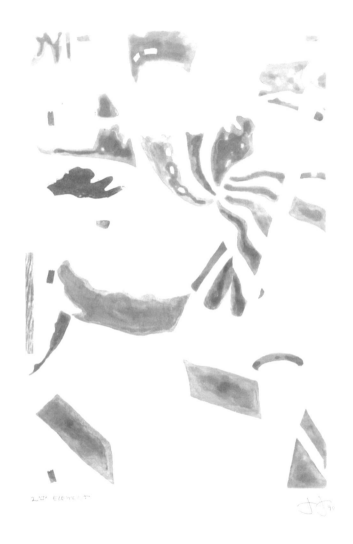

Cat. 28a. Second element, printed in orange

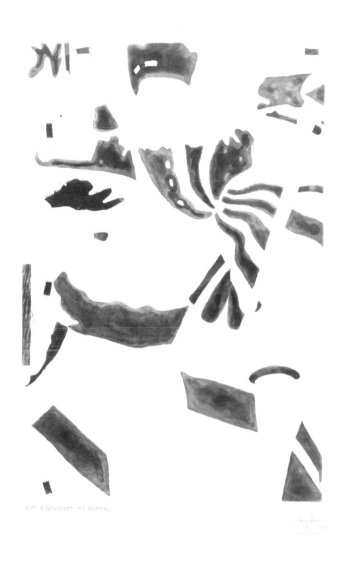

Cat. 28b. Second element, printed in black

3RD ELEMENT

Cat. 29a. Third element, printed in yellow

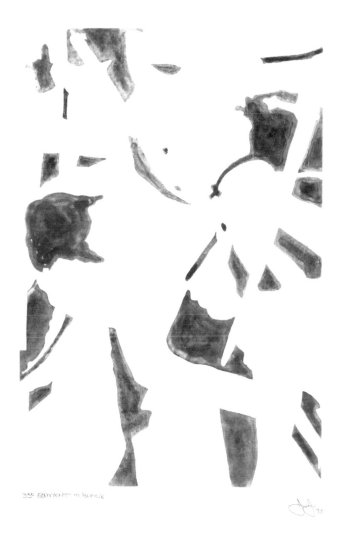

3RD ELEMENT IN BLACK

Cat. 29b. Third element, printed in black

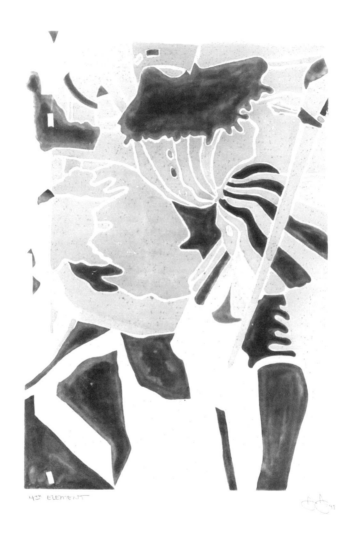

4ᵗᵈ ELEMENT

Cat. 30a. Fourth element, printed in red

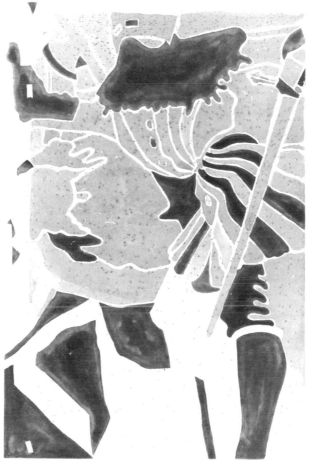

4TH ELEMENT IN BLACK

Cat. 30b. Fourth element, printed in black

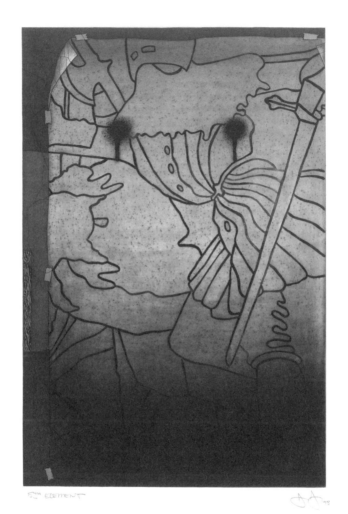

5TH ELEMENT

Cat. 31. Fifth element (key plate), printed in black

The Progressives

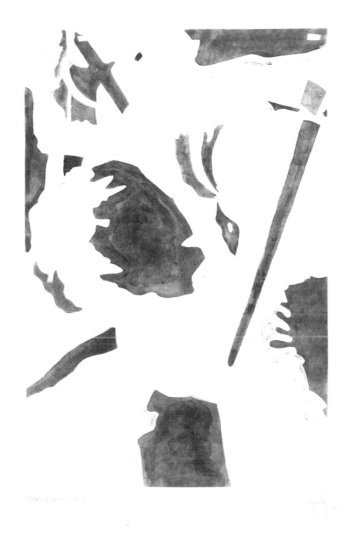

Cat. 32. First progressive proof (from the blue plate)

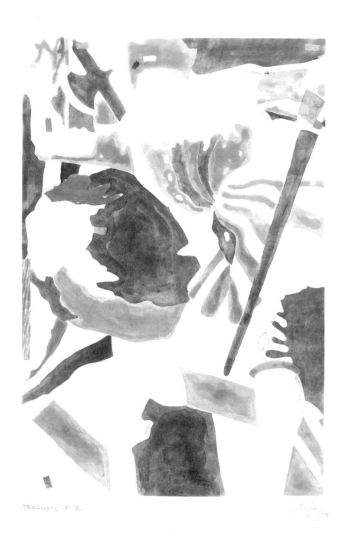

Cat. 33. Second progressive proof (from the blue and orange plates)

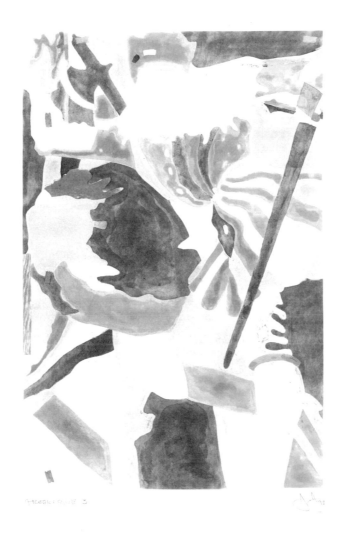

Cat. 34. Third progressive proof (from the blue, orange, and yellow plates)

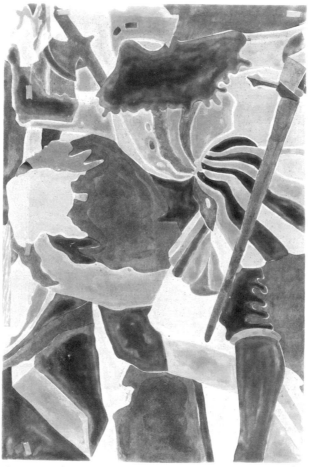

PROGRESSIVE 4

Cat. 35. Fourth progressive proof (from the blue, orange, yellow, and red plates)

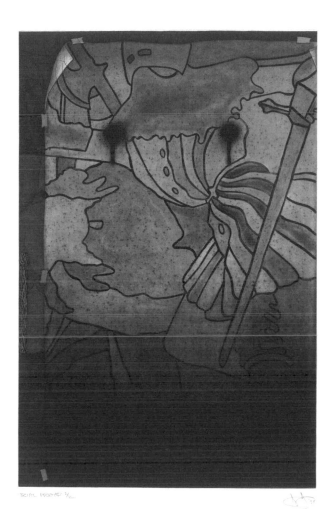

TRIAL PROOF ½

Cat. 36. Tenth trial proof, second of two, or "fifth progressive proof"
(from the blue, orange, yellow, and red plates and the black key plate)

The Copper Plates

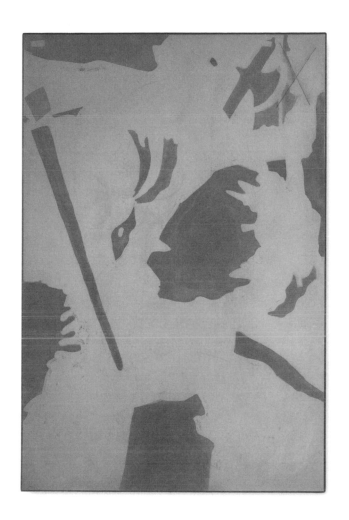

Cat. 37. Blue plate

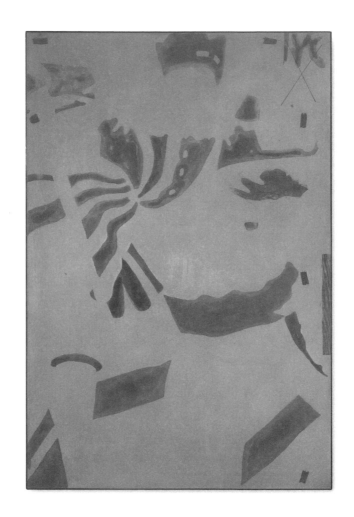

Cat. 38. Orange plate

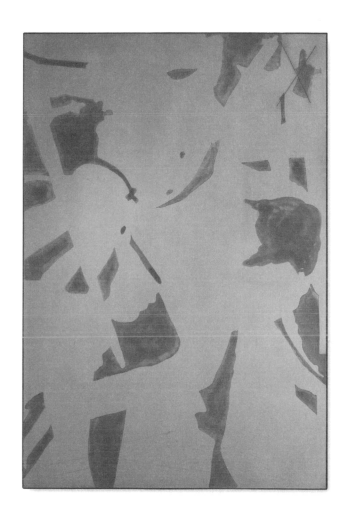

Cat. 39. Yellow plate

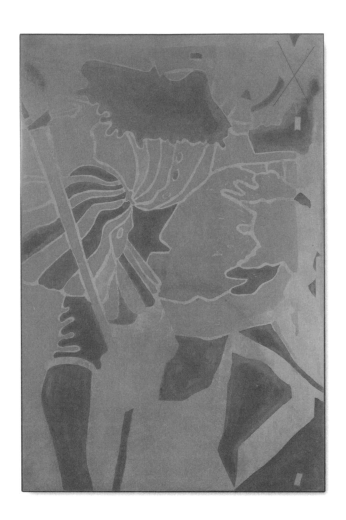

Cat. 40. Red plate

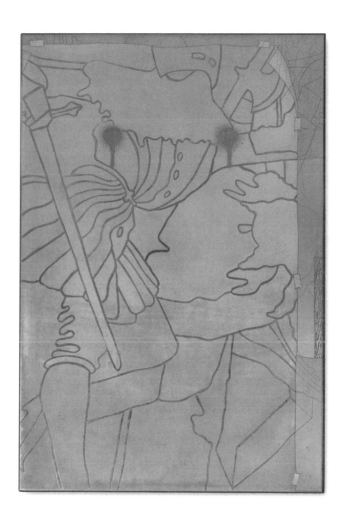

Cat. 41. Black (or key) plate

Jasper Johns: From Plate to Print was designed and typeset by Christopher Sleboda and printed in West Haven, Conn., by Gist and Herlin Press. It was bound in Charlestown, Mass., by Acme Bookbinding.

The catalogue is set in the Swift and Hollander family of typefaces, designed in 1986 and 1987, by Gerard Unger, The Netherlands.